D0424137

TREASURES

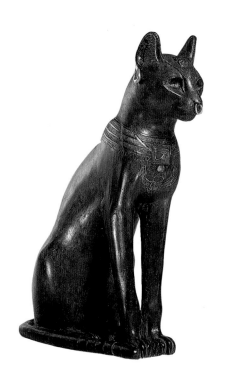

THE BRITISH MUSEUM

LITTLE BOOK OF
TREASURES

INTRODUCTION

The British Museum is one of the world's greatest treasure houses and at the same time one of its most respected academic institutions. Housed in Robert Smirke's imposing Greek Revival building set in the heart of London's Bloomsbury, it exudes an air of permanence appropriate to one of the first national museums. Yet this appearance is deceptive, for since its inception over two centuries ago the Museum has never ceased to grow and change, building on the knowledge of the past while pushing forward the frontiers of scholarship.

The British Museum came into existence on 7 June 1753 under the terms of the British Museum Act. The idea of a national museum had arisen out of the death of the noted collector Sir Hans Sloane, who in his will had offered the nation his natural history collection, antiquities and library in return for a £20,000 payment to his daughters. A national lottery was raised to purchase the collection, and some of the surplus used to buy the new museum a home – Monatagu House in Bloomsbury.

Once the Museum had a home, artefacts began to arrive in earnest: ethnographic material collected by Captain Cook on his Pacific voyages, the Hamilton collection of Greek vases, the Rosetta

Stone, the Bassae Frieze and the Parthenon Sculptures, to name but a few. Space to hold them all finally ran out, and Montagu House was demolished to make way for Smirke's present building, which was completed in 1847.

The 19th century was a time of exploration, discovery and trade. It was the age of the philanthropist, the polymath, the gentleman-scholar and the soldier-antiquarian. Ancient languages were being deciphered, archaeological methods invented, cataloguing systems developed. Within the Museum itself new Departments were created to reflect the increasingly specialised areas of study, and their Keepers began to organise and augment their collections in a disciplined manner.

The Museum has continued to expand throughout the 20th century, especially in the areas of research, conservation and education. It continues to fund archaeological excavations around the world (most notably at Ur in Iraq) and to add to its collections.

Every year over four million visitors come to the British Museum. For some it is a pilgrimage, for others a brief stop on the tourist trail. It is also a research lab, a classroom, an academic resource, a meeting place, a house of wonders. This book is intended to provide a taste of those wonders; hopefully it will also lure the visitor back for a second, third or hundredth visit.

Snettisham Torc

British, 1st Century BC

An ancient ornament commonly associated with the Celts, the torc is a heavy metal collar or neck-ring. Its name derives from a common form comprising a hoop of twisted metal strands ending in expanded terminals. Although classical writers such as Polybius described gold torcs as being worn by warriors, those in bronze have come almost exclusively from the graves of women.

This spectacular torc, presented to the Museum by the National Art Collections Fund, was one of a large number of antiquities recovered from a field at Snettisham in Norfolk. Made of an alloy of gold, silver and copper, its hoop (diameter 19.5 cm) comprises eight strands of twisted wire secured by twin looped terminals. Cast by the lost-wax method, these terminals are a fine example of the flowing British late Iron Age art style.

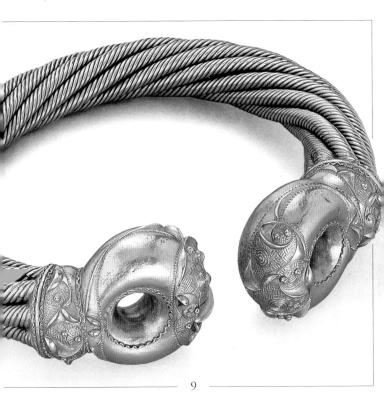

Lewis Chessmen

Scandinavian, middle of 12th century ad

These remarkable medieval chessmen were discovered in 1831 in a small buried stone structure on the shores of Uig Bay on Lewis in the Outer Hebrides, a group of small islands off the northwest coast of Scotland. According to tradition the peasant who broke into their underground hiding-place while digging mistook the little figures for a party of elves or gnomes and fled in panic. His reaction is easily understandable when we see the expressive features of the grim kings, anxious queens and fierce warriors.

In all, 93 pieces – carved from walrus ivory – were found,

including 14 draughtsmen, a belt-buckle and 78 chessmen, perhaps representing the remains of four sets. Of these, 82 are now in the British Museum, the remainder in the National Museum of Antiquities of Scotland in Edinburgh. Chess has been played in Britain since at least the 11th century, in which time little has changed. Apart from the rooks (castles) which are represented by sword-wielding warriors, all the pieces are immediately recognisable to the modern player. In order to distinguish the two sides during play, some were originally stained a dark red.

The finely carved interlaced foliate and animal designs on the thrones of the seated figures have enabled scholars to identify them as the work of a 12th-century Scandinavian craftsman, although where they were made and how they came to be buried on Lewis remain unsolved mysteries.

PORTLAND VASE

ROMAN, EARLY 1ST CENTURY AD

As famous for its chequered history as for its superb craftsmanship, the Portland Vase probably dates from the early 1st century AD. Its name derives from the 3rd Duke of Portland, who first loaned it to the British Museum in 1810. In 1845 disaster struck in the form of a drunken visitor who deliberately smashed the vase and its case using another piece from the same gallery. The vase, which had been broken into almost 200 pieces, took ten years to repair.

It was probably made in Italy, where the technique of manufacturing cameo-glass is now thought to have originated. This intricate process involved flashing (coating) a blown dark-coloured body (here a translucent cobalt blue) with a thin layer of opaque white glass which was then cut away to create a shaded, three-dimensional effect. The scenes on the vase may represent the courtship of Peleus and Thetis, suggesting that it could have been made as a wedding gift.

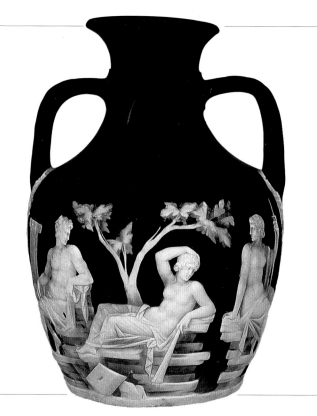

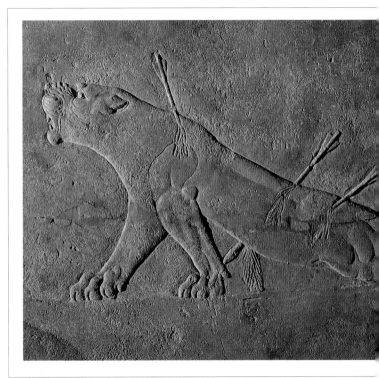

DYING LIONESS

ASSYRIAN, c.645 BC

Lions have long been associated with kingship, perhaps because of their great power and ferocity. In ancient Assyria, where they also represented hostile forces that could threaten the nation, hunting them became both a royal sport and a symbolic gesture signifying the ruler's triumph over evil.

In the lion-hunting reliefs from the walls of the palace of Ashurbanipal at Nineveh, the hunt takes place in an enclosed ground surrounded by armed soldiers. All the details of the chase have been faithfully recorded by the sculptor, as can be seen in this carving of a dying lioness, who despite the blood pouring from her many wounds, roars defiantly as she tries to drag herself to her feet.

TURQUOISE MOSAIC SERPENT

MEXICO, 15TH-16TH CENTURY AD

The turquoise mosaics in the British Museum are of the kind given to the Spanish conquistador Hernán Cortés by the great Aztec ruler Moctezuma, after Cortés' arrival in Mexico in 1519. This double-headed serpent is carved from wood, which has been hollowed out at the back. The body is encrusted with a mosaic of turquoise which covers both the front and reverse of the heads. The teeth are formed from white shell, while the gums and nostrils are picked out in pink shell, as is the decorative band above the nose. The eyes would probably have been discs of polished iron pyrites set into white shell. It probably served as an ornament at the back of a headdress, but it could also have been worn as a pectoral.

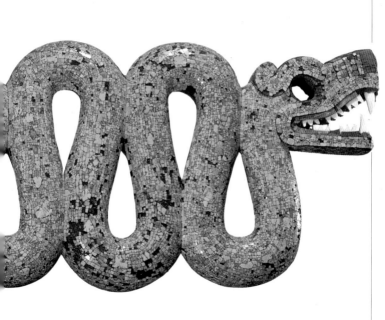

MAHAKALA

TIBET, 19TH CENTURY AD

Painted banners, or *thangkas*, play an essential role in the ritual of the different Buddhist schools of Tibet and Nepal, where they serve as objects of devotion and meditational aids. Among the characteristics of this tradition of Buddhist practice is the veneration of fearsome deities known as Protectors. Although such violent figures seem at odds with the non-violent principles of Buddhism, their role is in fact to protect its teachings by repelling the forces of evil.

The form of Mahakala, regarded in Tibet as a wrathful aspect of the compassionate deity Avalokiteshvara, owes much to the Hindu god Shiva. Shown here as Protector of Science, he has a bloated blue-black body crowned and garlanded with skulls and freshly severed heads. In his four hands he holds a sword, a trident, a fruit and a skull-cup filled with blood. The naked figure crushed beneath him symbolises the destruction of ignorance that keeps living beings chained to the cycle of existence.

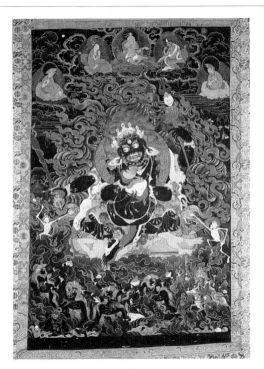

PARTHENON FRIEZE

GREEK, 5TH CENTURY BC

The Parthenon on the Acropolis at Athens was built between 447 and 432 BC and dedicated to the goddess Athena, daughter of Zeus. It was decorated with marble sculpture in the round and in relief. The frieze, set high up under the ceiling of the colonnade, is carved in very shallow relief. Nevertheless, its complex design is full of both lively action and sombre majesty. Pride of place on the two long sides was given to a cavalry parade. The subject of the whole was linked to the procession every fourth year that brought a new robe for Athena on her birthday: the scene of the central section of the East side.

The sculptures from the Parthenon on the Acropolis at Athens were brought to this country at the beginning of the nineteenth century by the 7th Earl of Elgin and purchased for the Museum in 1816.

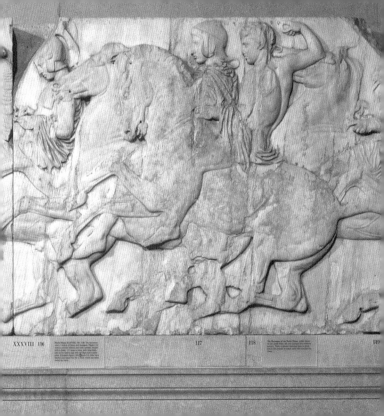

North frieze XLVIII, 116–118. The horsemen
wear a variety of dress and trappings. Figure 116
wears a crested helmet and tunic without straps
held with a belt. 117 wears a cloak over a tunic
held on the right by a clasp. His short chiton is
pushed up in folds on the thigh. 118 rides bare-
headed and naked but for a cloak which can...
round the waist.

The Horsemen of the North Frieze, whose horses
in the profile forms, are cut against the relief
ground. There is almost identical lines in their
actions the sculptor is visible with their heads by the
horse.

MUMMY AND COFFIN OF A PRIESTESS

EGYPTIAN, *c*.1000 BC

This fine anthropomorphic coffin belonged to an unnamed Theban priestess who is represented on the lid, wearing a heavy wig and garlanded with flowers. Found complete with her neatly bandaged mummy, it is painted inside and out with figures of gods and sacred texts intended to protect her on her journey through the underworld.

The first Egyptian experiments in mummification took place around 2500 BC; a thousand years later it had become a sophisticated art. In the case of rich patrons who could afford the full treatment, the corpse was taken to the embalmers' workshop, where the internal organs were removed and the body dried out with natron. Sometimes the treated organs were

returned to the body cavity, but generally they were kept separate and the cavity stuffed with linen or sawdust. It was then sewn up and the body wrapped in linen bandages. The whole process with its attendant rituals took 70 days, after which the body was placed in its wooden coffin for the journey to the tomb.

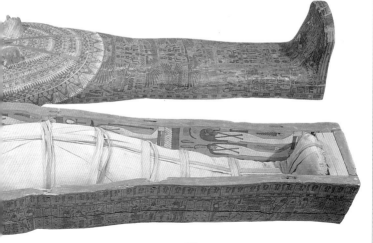

A Young Woman Sleeping

by Rembrandt van Rijn

Dutch, c.AD 1655

Rembrandt van Rijn (1606-69) was one of the foremost 17th-century Dutch painters and is famous for his handling of light and shade, especially in his portraits. This sketch of a young woman sleeping is one of a small group of brush drawings in brown wash thought to have been executed by him around the middle of the century.

The model was probably Hendrickje Stoffels, who lived with the painter from around 1649 until her death in 1663, and bore him a daughter, Cornelia. Hendrickje appears in a number of Rembrandt's paintings, including the *Woman Bathing* of 1654 in the National Gallery, London. This drawing was purchased by the British Museum in 1895 as part of the famous collection of drawings and prints formed by John Malcolm of Poltalloch.

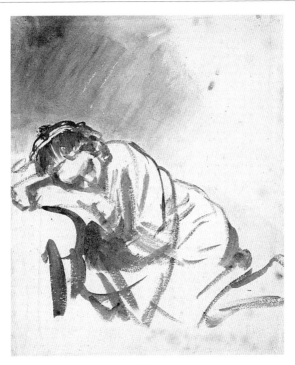

THE ROSETTA STONE
EGYPTIAN, 196 BC

It may not be among the most beautiful exhibits, but the Rosetta Stone (height 114 cm), which provided the key to the decipherment of ancient Egyptian writing, is nonetheless one of the British Museum's greatest treasures. It was discovered in 1799 by French military engineers working at Rosetta (modern Rashid) in the Nile Delta. Such fragments of reused ancient masonry were common, and it would probably have been discarded had it not been for the officers in charge of the party who guessed that its inscription – in Greek, hieroglyphics and Demotic – might be of significance. Copies of the inscription were sent to scholars around the world. Having read the Greek version of the text – a priestly decree listing the gifts of Ptolemy V to various temples – they were able to find the hieroglyphic equivalent of certain words such as royal names and by comparing these with other sources slowly unravelled the mysteries of the ancient Egyptian language.

SHIVA VISHAPAHARANA

CHOLA, *c.*AD 950

Shiva, the creator and destroyer, is one of the three principal Hindu deities and figures prominently in Indian myth. In this magisterial bronze (height 59 cm) of Shiva Vishapaharana (Shiva destroying Poison), the god is shown seated on a throne in the position of royal ease, his right foot resting on a lotus. His body is adorned with fine jewellery; he wears odd earrings indicative of his dual male/female nature. A crescent moon rests in his piled-up matted hair, the hair of the wandering and homeless ascetic. In accordance with convention, he is shown with four arms in order to display attributes and gestures suggestive of his infinite qualities. His upper hands hold an antelope, referring to his life as a forest yogi, and an axe, symbolic of the cutting of the bonds of ignorance. His lower left hand holds a cobra representing the poison of this myth, while the right makes the gesture of reassurance.

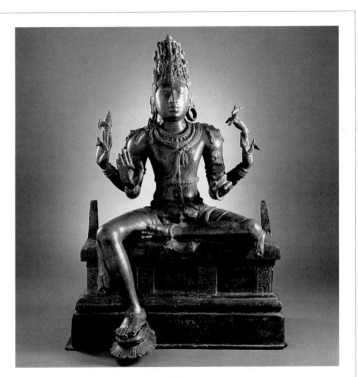

HINTON ST MARY PAVEMENT
ROMAN, 4TH CENTURY AD

The Hinton St Mary mosaic is one of the most striking pieces of evidence for Christianity in Roman Britain. It was discovered during the excavation of a Roman villa at Hinton St Mary in Dorset in 1964 and removed to the British Museum the following year. It was designed as a continuous floor for two adjacent rooms and the detail shown here is from the larger of these. A central roundel contains the head and shoulders of a clean-shaven man in Roman dress. This central position is often occupied by the picture of a god or goddess. The bust is flanked by pomegranates, symbols of immortality, while behind the head are the Greek letters chi (X) and rho (P), the first two characters of the name of Christ. The use of this standard early Christian monogram suggests that the central bust represents Christ himself, and if so the Hinton St Mary pavement includes one of the earliest known portraits of Christ.

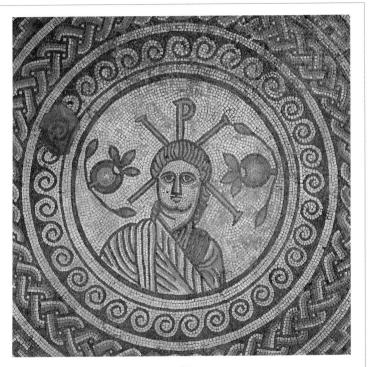

ROYAL GOLD CUP

FRENCH, *c.*AD 1380

The Royal Gold Cup of the kings of France and England was probably commissioned as a gift for Charles V of France by Jean, Duc de Berry. After the king's death it passed to his son, Charles VI, and from there went to England, where it graced the tables of Henry VI and all the later Tudor monarchs. The Tudors added a new stem to the cup, decorated with their own enamelled roses. In 1604 the Stuart James I gave it to the Constable of Castile to mark the conclusion of an Anglo-Spanish peace treaty.

Made of solid gold (height 23.6 cm), the cup is enamelled in bright translucent colours with scenes from the life of St Agnes, a Christian Roman girl who preferred martyrdom to marriage to a pagan. The theme was probably chosen because Charles V was born on St Agnes Day. Around the base are the symbols of the four evangelists. Despite this religious imagery, there is no evidence that the cup had any liturgical function.

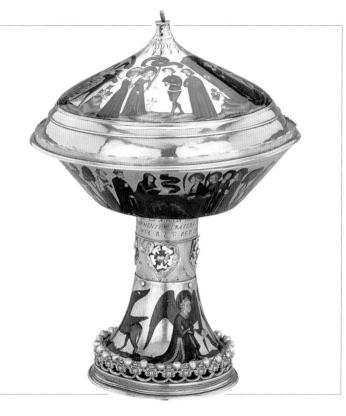

LE JOCKEY BY HENRI DE TOULOUSE-LAUTREC
FRENCH, AD 1899

Despite an aristocratic background that set him above such an occupation, Toulouse-Lautrec (1864-1901) was determined to devote his life to art. In 1882 he began to study painting in Paris, where he subsequently established his own studio. Although he began as a painter, the 1890s saw him turn increasingly to printmaking, especially the exciting new technique of colour lithography. His themes were almost always drawn from the city's lowlife haunts – dance halls, brothels and theatres. *Le Jockey*, one of his last works, was intended as one of a series of racetrack subjects which remained unfinished because of the artist's poor health. This version is one of 12 six-colour lithographs on Japan paper and was bequeathed to the British Museum in 1949 by a former Keeper of the Department of Prints and Drawings. One hundred colour impressions on ordinary paper and a black-and-white edition of 100 were also published.

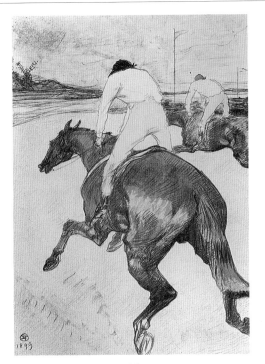

Sutton Hoo Helmet
Anglo-Saxon, 7th century AD

In 1939 an intact Anglo-Saxon ship-burial was excavated on the Suffolk estate of Mrs Edith M. Pretty, who presented its contents to the nation. Because of its astonishing wealth it is thought to be a royal grave, possibly that of Redwald, king of the East Angles and overlord of the Anglo-Saxon kingdoms, who died c.AD 625.

Among the many treasures excavated was this magnificent helmet. The helmet is made of iron with the cap, face-mask, ear-flaps and neck-guard all covered with thin sheets of tinned-bronze that would originally have given them a bright, silvery appearance. It has cast bronze eyebrows inlaid with silver wire and set with small square-cut garnets, and a face-mask with a realistically modelled nose and mouth of gilded bronze. The panels covering the helmet are impressed with four different designs, two with interlacing animals and two with figural scenes.

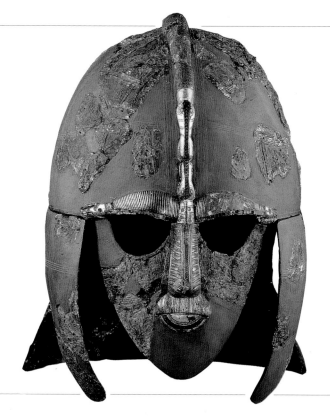

MILDENHALL GREAT DISH

ROMAN, 4TH CENTURY AD

One of the finest examples of metalwork to survive from antiquity, the Great Dish is the major piece in a large hoard of 4th-century Roman silver tableware discovered at West Row near Mildenhall in Suffolk in the early 1940s. The dish (diameter 60.5 cm) has a beaded rim and raised figures in low relief. In the centre is the head of the sea-god Oceanus, surrounded by a frieze of mythological sea-beasts and nereids (nymphs). The outer frieze shows the triumph of Bacchus, the Roman god of wine, over the hero Hercules in a drinking contest. Bacchus, accompanied by his associate Silenus, rests his foot on the haunches of his panther while the god Pan, his pipes in hand, dances with satyrs and maenads, the female devotees of Bacchus. Hercules, recognisable by his club and lionskin beside him, is clearly beaten; two satyrs struggle to support him in his drunken stupor as all around them the revels continue.

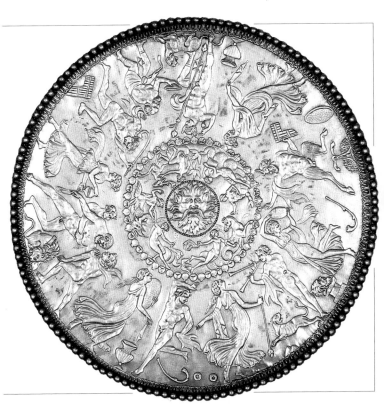

GOLD BRACELET

ACHAEMENID, 5TH-4TH CENTURY BC

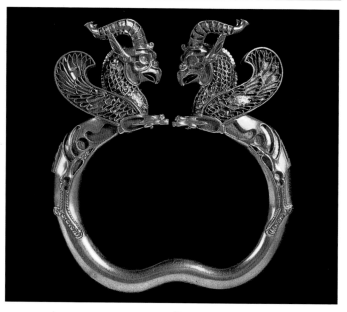

The Achaemenid Persians, named after their legendary ancestor Achaemenes, established their empire in Iran, the Near East and Central Asia around the middle of the 6th century BC. Building on the long-established metalworking traditions of the region, their smiths went on to produce magnificent jewellery and tableware.

Some of the finest-known examples of their work come from the Oxus Treasure, a spectacular find of gold and silverware discovered near the River Oxus in 1877. The treasure was to be taken to India to be sold, but on the way the merchants carrying it were robbed by bandits. Most of the pieces were recovered by a British officer, Captain F.C. Burton.

The bracelet probably belonged to a temple where offerings had accumulated for several centuries before being buried sometime around 200 BC. One of a pair executed in the distinctive Achaemenid style, it has horned griffin terminals that were originally inlaid with enamel and semi-precious stones.

ICON OF ST JOHN THE BAPTIST

BYZANTINE, *c.*AD 1300

Icons – painted images of Christ and the saints – have served as objects of veneration among Orthodox Christians from medieval times to the present day. This fine icon of St John the Baptist, probably commissioned by a wealthy Byzantine for private devotion, was purchased by the British Museum in 1986 with the help of the National Art Collections Fund, British Museum Publications Ltd and Stavros Niarchos, Esq.

Painted in egg tempera on a wooden panel (25.1 x 20.2 cm) faced with gesso and linen, the half-figure of the saint is set against a gold-leaf background. He wears a green mantle and red tunic over a hair shirt; his right hand is raised in blessing, his left holds a scroll. He is identified by a Greek inscription to either side of the halo which reads: 'St John the Forerunner'.

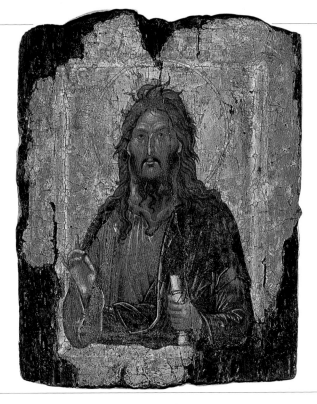

STANDARD OF UR

SUMERIAN, *c*.2500 BC

This enigmatic object is just one item of the vast treasure recovered by Sir Leonard Woolley from the Royal Cemetery at Ur near the River Euphrates in Iraq.

The Standard – so called by Woolley, who thought it might have been an emblem carried on a pole – was possibly the sounding-box of a musical instrument. It is 20.3 cm in height and has sloping wooden sides, now restored, which were covered in bitumen and overlaid with a mosaic of shell and red limestone set against a background of lapis lazuli. The damaged trapezoidal end panels showed animal or mythological scenes, while the rectangular main panels are known as 'War' and 'Peace' because they illustrate a military victory and a celebration banquet.

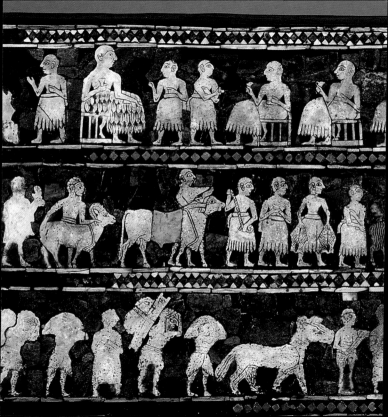

MEDAL OF QUEEN ELIZABETH I
NICHOLAS HILLIARD, *c*.AD 1580-90

In 1588 all England waited in trepidation for the arrival of the Spanish Armada. For three years Philip II, the Catholic king of Spain, had been building a fleet intended to bring Protestant England to its knees and prepare the way for a Spanish invasion. In the event the greatest fleet the world had ever seen was defeated by adverse weather and the skill of the English commanders.

The so-called Armada medal 'Dangers Averted' was perhaps executed shortly afterwards, probably as a gift from Queen Elizabeth I herself, and was designed by the celebrated miniaturist and goldsmith Nicholas Hilliard. On the obverse a portrait of Elizabeth wearing a magnificent court dress and holding the insignia of royalty is surrounded by the Latin legend *ditior in toto non alter circulus orbe* (no other circle in the whole world more rich). The reverse has an allegorical scene in which a bay tree, representing the Queen,

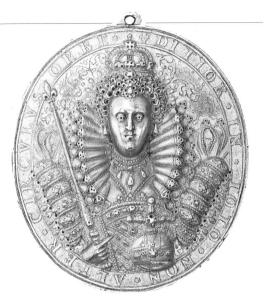

deflects lightning, symbolising the wrath of Heaven, away from the island – Britain – on which it stands and towards the surrounding sea. The inscription beneath the tree reads *non ipsa percula tangent* (not even dangers affect it).

GAYER-ANDERSON CAT

EGYPTIAN, *c*.600 BC

This fine example of Saite bronze casting was presented to the British Museum in 1939 by John Gayer-Anderson, a British soldier and Orientalist who had settled in Egypt.

Cats enjoyed a special status during the Late Period (747-332 BC) as the living forms of the goddess Bastet. During life they were pampered – even household pets might wear gold or silver earrings of the type seen here – and when they died they were carefully mummified and buried in special cemeteries, sometimes in individual sarcophagi. From early times the Egyptians had associated cats with the sun, and this piece is rich in solar imagery. Around its neck is a silver plaque representing the sacred eye of the solar deity Horus, while on the head and breast are images of scarab beetles symbolising the rising sun.

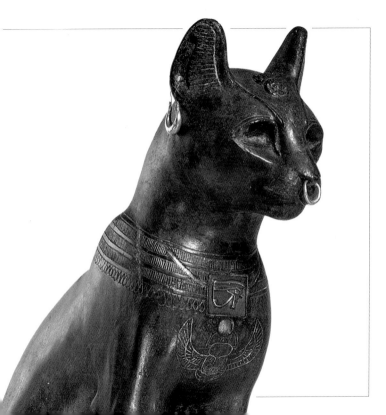

MING FLASK

CHINESE, AD 1426-35

The surface of this large flattened flask (bian hu) is covered liberally with the stems, leaves and flowers of the lotus and with sprays of *lingzhi* fungus. The attractive adornment was painted onto the flask using a cobalt blue pigment imported at great expense from Persia. The flask was then covered with a glaze which vitrified when fired at a very high temperature – 1500° C.

The finest Ming dynasty blue-and-white wares were produced during the reign of the Emperor Xuande and embellished his palaces and temples. The porcelains were subjected to stringent quality-control procedures. Even the smallest imperfection meant that a piece had to be destroyed. Recent excavations of the 15th-century rubbish tips at the Imperial kilns in Jingdezhen have revealed thousands of flawed and rejected porcelains bearing Imperial marks.

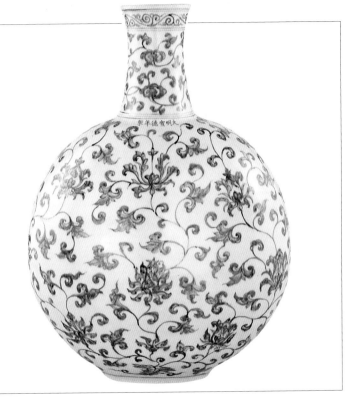

Maya Lintel

Mexican, c.AD 770

This is one of a group of stone lintels from the Maya city of Yaxchilan, constructed between AD 400-800 at a site on the Usumacinta river near the present border between Mexico and Guatemala. Many of the buildings in the city were erected to mark royal events; some were also used for the elaborate religious rituals required on such occasions. The lintels, carved to commemorate the accession to power of Lord Bird Jaguar, illustrate in graphic detail the blood-letting rites performed in order to contact ancestral spirits, ensure success in battle and obtain captives for sacrifice. Here, one of Bird Jaguar's wives is shown kneeling: she holds a basket containing blood-spotted paper strips, a lancet and other blood-letting implements. Before her a vision of an ancestor emerging from the mouth of a serpent arises from a bowl filled with blood-stained paper.

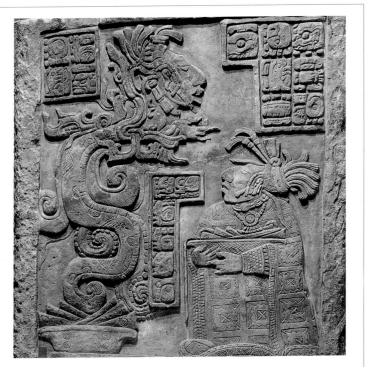

Amphora

Athenian, *c.*540-530 BC

This magnificent example of the potter's art was both made and decorated by the celebrated Athenian vase-producer Exekias around the mid-5th century BC. Like much Athenian black-figure ware of the period, it was probably produced for use at a drinking party, or symposium; two-handled amphorae of this type were used for the storage of wine.

From the early 6th century onwards, Athenian vase-painters had concentrated on representing the human form, drawing their subjects from everyday life or from mythology. Here the painting illustrates a dramatic episode in the Trojan War: the death of the Amazon queen Penthesileia at the hands of the Greek hero Achilles. According to tradition, at the moment of Penthesileia's death her eyes met those of Achilles and the pair fell hopelessly in love; the way in which Exekias manages to convey the tragedy of this instant is the most eloquent tribute to his skill.

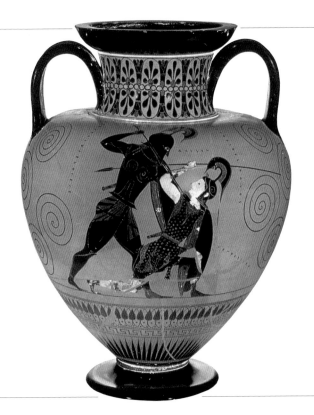

OXBOROUGH DIRK

BRONZE AGE, *c*.1500-1350 BC

One of the British Museum's most recent acquisitions, purchased with help from the National Art Collections Fund, the Oxborough Dirk is a magnificent bronze ceremonial weapon. Although it is modelled on contemporary functional dirks, its dimensions (length 70.9 cm), deliberately blunt edges and lack of provision

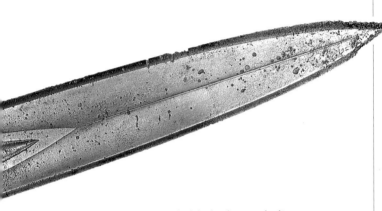

for hafting indicate that it probably had a symbolic rather than a practical purpose. The dirk is the first of its type to have been found in Britain.

The dirk was discovered in 1990 in a peat bog at Oxborough, Norfolk; it seems to have been deliberately deposited in the bog, perhaps as an offering to a deity.

ASUKAYAMA AT CHERRY BLOSSOM TIME
BY TORII KIYONAGA
JAPANESE, *c*.AD 1785

Torii Kiyonaga (1752-1815) was one of the greatest and most innovative exponents of the ukiyo-e school of Japanese printmaking, which originated in the 17th century and illustrated the pleasures of the citizens of Edo (modern Tokyo).

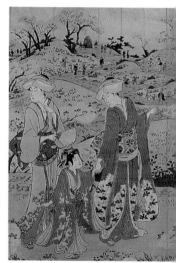

Kiyonaga's chief contribution to the genre was to set his prints in the open air, investing them with a depth derived from his experiments with Western-style perspective. At the same time he extended his compositions across two or three

sheets to produce wide and connected landscape effects. His figures were taller, more relaxed and elegant than those of his predecessors. All of these qualities can be seen here in this scene of richly-dressed women enjoying the spring blossom.

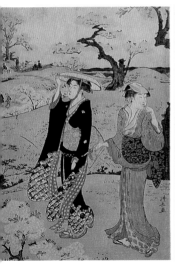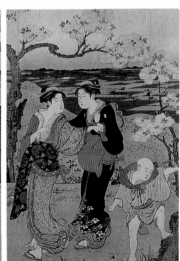

ACCESSION NUMBERS OF OBJECTS ILLUSTRATED

© 1996 The Trustees of the British Museum

First published in 1996 by The British Museum Press
A division of The British Museum Company Ltd
46 Bloomsbury Street, London WC1B 3QQ

Originally published as *The British Museum Pocket Treasury*

Paperback edition 2004

A catalogue record for this book is available from the British Library

ISBN 0-7141-5030-4

Text by Delia Pemberton
Photography by the British Museum Photographic Service
Designed by Butterworth Design
Cover design by Harry Green

Typeset in Garamond
Printed in Hong Kong
by H&Y Printing Ltd